Paul Klee

GREAT ART OF THE AGES

———————

GREAT ART OF THE AGES

Paul Klee

Text by WILL GROHMANN

Harry N. Abrams, Inc. Publishers New York

MILTON S. FOX, *Editor-in-Chief*

Standard Book Number: 8109–5121–5

Library of Congress Catalog Card Number: 69–19710

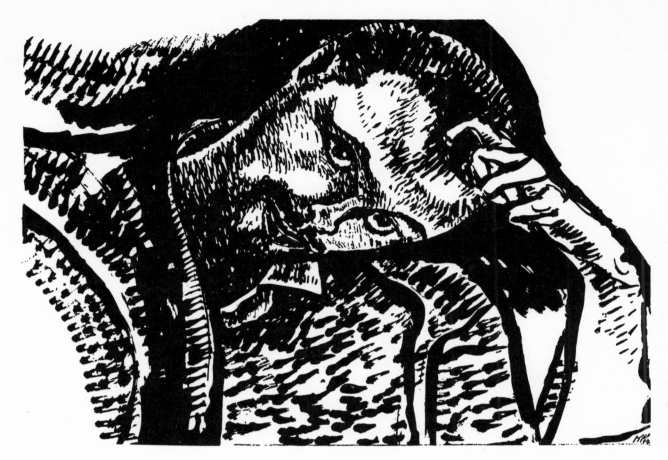

Paul Klee

(1879–1940)

PAUL KLEE WAS ONE OF THE PIONEERS of a new art who belong to the generation born around 1880; since his death in 1940, his fame has been steadily growing. Because he developed slowly, and, as he put it, "began with the smallest things," building stone by stone, his truly creative period covers no more than twenty years, from his appointment to the Bauhaus in Weimar to his death in Bern. During those two decades he produced the works which embody the unique quality of his genius. Despite their relatively small size, his pictures have their place in every art collection beside the larger paintings of Picasso, Braque, and Miró, for they are quite different, as though created on another planet. They are perfect in themselves, flawless applications of artistic techniques Klee himself invented, and, beyond that, they penetrate into provinces that had hitherto been closed to painting—music, poetry, and even philosophy. Why should not the painter be also a poet and a philosopher, Klee asked. In order to be able to paint as he had dreamed of painting, and achieve a complexity of statement equal to that of the poet, the composer, or the philosopher, he had to go a long way.

Klee's works were at first appreciated only for their most conspicuous features: he obtained his earliest successes with those sheets on which nightingales sing, stars shine over the rooftops at night, or actors play out imaginary performances.

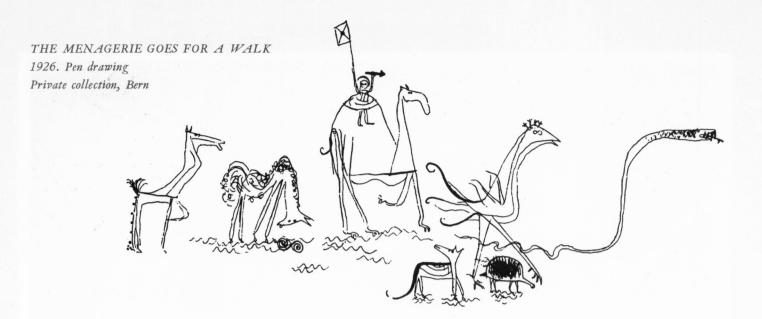

He was admired for his personal romanticism and humor. Now it is true that throughout his life Klee displayed a strongly marked romantic inclination for satire and playful contrasts, as well as a philosophical sense of humor; even in his last years, in the shadow of illness, he executed drawings testifying to his good-natured receptivity to bizarre situations. What was overlooked at the time, however, was the originality of Klee's art. He never *began* with a poetic idea: he *arrived* at the poetic, and he did so by means of his particular art.

Today there is a tendency to fall into the other extreme—to emphasize Klee's inventiveness and his great artistic skill at the expense of his extraordinary ability to communicate human or universal content through paintings and drawings. In Klee the process of artistic creation is intimately connected with the process of self-expression: he painted what he himself was.

Klee received an entirely normal education. He attended the *Gymnasium* in his native Bern, he studied in the art school at Munich, he traveled in Italy, and after five years in Bern returned to Munich, where he lived from 1906 to 1920. In Munich he found exhibitions, music, friends, and eventually understanding and recognition. In the year when the artists' group *Der Blaue Reiter* (The Blue Rider) was founded, he met Kandinsky, Marc, Macke, Jawlensky, and Arp; he also met writers and scholars, and in 1914 he went to Kairouan with Macke and Moilliet, a childhood friend from Switzerland. It was only during that trip that he became a painter—"color has taken hold of me," he wrote in his journal.

By then Klee had gradually advanced from drawings and etchings to paintings on glass, and to "tonal," that is, monochrome or black-and-white, watercolors; but even though he had been interested in color, and his meeting with Delaunay in Paris had clarified many things for him, he became a painter

OPPOSITE PAG
GIRL WITH JUG
Commentary on page 4

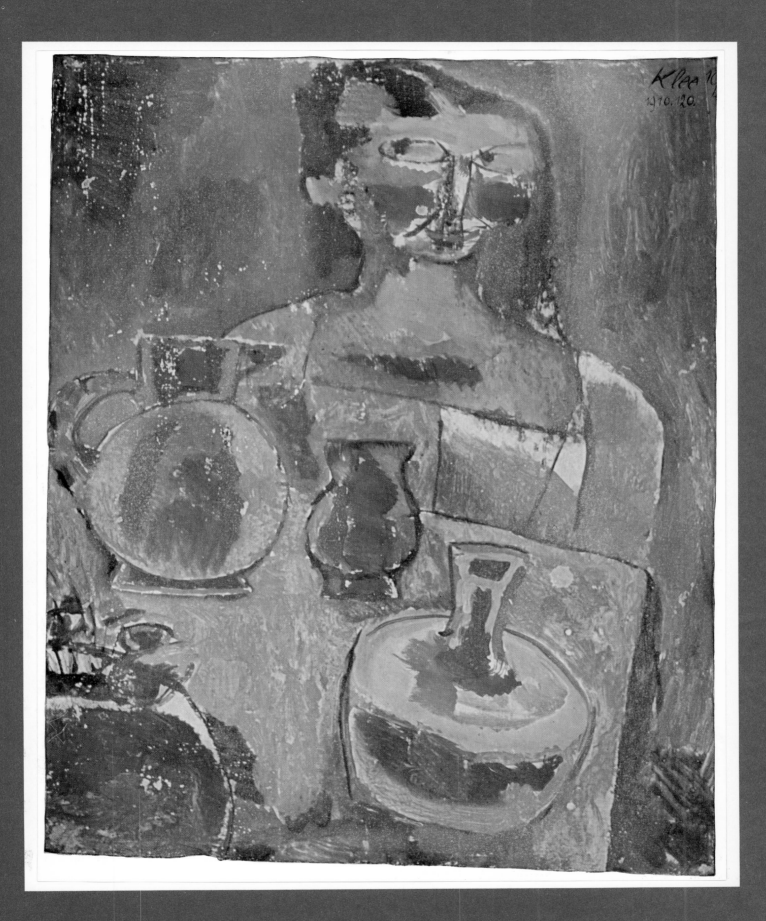

MIGRATORY BIRD
1925. Pen drawing
Private collection, U.S.A.

only in 1914, when he began the long series of watercolors which in 1919 were followed by oils. Two and a half years of military service in Bavaria interrupted his work, but fortunately even then Klee found occasional opportunities to draw and paint. His last years in Munich were particularly fruitful, and successful as well: he gained public recognition, and by the end of 1920 he was invited to join the newly founded Bauhaus in Weimar. He remained in Germany until 1933. Publicly denounced by the Nazi government, he returned to his native Bern. During the remaining six and a half years of his life, despite severe illness, he perfected his *oeuvre*.

Klee's greatness lies in the energy with which he conceived a succession of artistic projects, ascending from one conception to the next, and in the end summing up the results he had achieved. When we pass his works in review, we find that he was the author of approximately thirty such projects; we might designate them by the scientific term "schemata."

An example will illustrate the meaning of this term. What is originally a chessboard pattern of colored squares and rectangles becomes, after 1923, a piece of architecture, a flowering tree, or the portal of a mosque. But in each case it is not the desire to represent the architecture, tree, or mosque that leads to the form of the picture, but vice versa: the formal elements—the square, rectangle, et cetera—produce the images. In point of fact, this schema of the chessboard pattern holds certain analogies with Schönberg's twelve-tone system, and we might in both cases speak of "magic squares." But whereas Schönberg adhered to his schema for a long time, although permitting variations, Klee proceeded to new schemata, for instance, to fugal phrases, translucid bands of color intersecting at right angles, with or without graphic elements, and so on. While remaining faithful to himself, Klee was probably the modern painter richest in metamorphoses, even though the changes in his formal images are less drastic than in Picasso's, since all of them are related to a center, to a basic conception.

Klee's basic conception may be defined as follows: The main purpose of art is not to *render the visible*, but rather to *make visible*. Cézanne was still concerned with the object and with space; Cubism strove to represent the three dimensions on the flat surface. Klee seeks to render also that which is *invisible*; he aims at a "total" view. To begin with he expands his object by including its inner being: he opens it up, he shows it in cross section, he describes its functions; he is thus simultaneously an anatomist and a physiologist. But he does not stop there: he seeks to show the object in its relations to the earth and to the universe. He traces its terrestrial routes, and discloses its unity with the cosmos, he comes to grips with both its statics and its dynamics. To stand *and* to fly! But "all vistas intersect in the eye." Klee's pictures differ from the optical image of an object, but do not contradict it from the standpoint of totality. Long before the German philosopher Martin Heidegger, Klee invented the "foursome": I, Thou, earth, and cosmos.

Whether all this results in a work of art depends of course on the artistic means used. To develop the artistic means is, in Klee's view, the painter's task. He thought that it was wrong to start from the forms which are the end products of nature; he starts from the initial forms, he proceeds like nature, genetically. He says that the work of art is first of all a process of creation, and that the Book of Genesis is a perfect parable of the artistic process.

Klee's forms develop spontaneously but not arbitrarily; as living entities they must be attuned to the essence of reality in such a way that they, so to speak, respond to reality. With Goethe he thinks that "an unknown law in the object corresponds to an unknown law in the subject." The artist's instinct and hand thus follow laws common to nature and art. According to Klee, the opposition between objective and non-objective art is irrelevant—he is concerned only with the how of the object.

Klee is never abstract, not even in his seemingly non-representational, or as he preferred to call them, "absolute," pictures. But he is not "objective" either; whatever references to

EMIGRATING
1933. Pencil drawing
Klee Foundation, Bern

objects we find in his works arise by way of association, which is induced spontaneously, starting from the "foursome" of the creative act. "For every highly organized structure can, with a little imagination, be compared with familiar structures of nature." Klee accepts the associative reference, and after completing a given work identifies it with an object: for instance, he names one of his paintings the "Voice Cloth of the Singer Rosa Silber," rather than "Accent in Rose." But this does not mean a return to nature. The painter himself is nature, and places himself within it.

In the twentieth century the work of art has become a "speculative phenomenon"; the conscious is as active in Klee's pictures as it is in those of his contemporaries. But the unconscious is predominant; it is attracted by the very invention of the artistic means, the signs, the ciphers. The rational control enters only when the picture acquires a face. "Now it looks at me," Klee used to say at that point. The technique of the brush stroke is a great deal, but the crucial factor is intuition. "We construct and construct," Klee wrote in a Bauhaus prospectus, "and yet intuition is still a good thing. A considerable amount can be done without it, but not all. There is plenty of room left for exact research in art, but there is no substitute for intuition." Klee would never have admitted that art should become increasingly scientific.

According to him, "genius is an error in the system"—with these words he underlined the distinction between art and science. Had it been otherwise, how could the ambiguity of art conceal an ultimate mystery? "Art unwittingly plays a game with the ultimate realities, but nevertheless arrives at them. . . . The formal cosmos so closely resembles the Creation that a mere breath is sufficient to bring to life the expression of religious experience and of religion itself."

Klee left behind nearly 9,000 compositions—3,500 drawings and 5,500 colored sheets and panel paintings. He never repeated himself, and executed each of his pictures to illustrate his conception of the world and of art, a conception which was constantly renewed in his works.

PAINTED IN 1915

The Niesen

WATERCOLOR ON COLORED PAPER, $7\frac{1}{8} \times 9\frac{7}{8}''$

COLLECTION HERMANN RUPF, BERN

The Niesen (it is the name of a mountain near Munich) belongs to a series of "Kairouan" watercolors. Actually, it was done a year after the famous trip to Tunis which Klee had taken shortly before the outbreak of the First World War with his friends Louis Moilliet and August Macke. The artistic consequences of the trip Klee summarized as follows in his diary: "Color has got me . . . has got me for good. That is what this happy hour means. I and color have become one. I am a painter."

His interest in Delaunay, whom he had visited in Paris in 1912, now stood him in good stead; he now could profit from Delaunay's way of building up forms and objects in terms of light and color, from the rhythmic quality and the poetic feeling in Delaunay's work. At the same time he continued to show the influence of Cézanne's "modulation" of color, which proceeds from several centers in Klee's picture and results in a kind of honeycomb pattern.

The lower half of *The Niesen* shows exactly the same treatment as the "Kairouan" watercolors, while the mountain and the sun, moon, and stars of the upper half are done with great distinctness and hint at new directions because of their emphatic representational meaning.

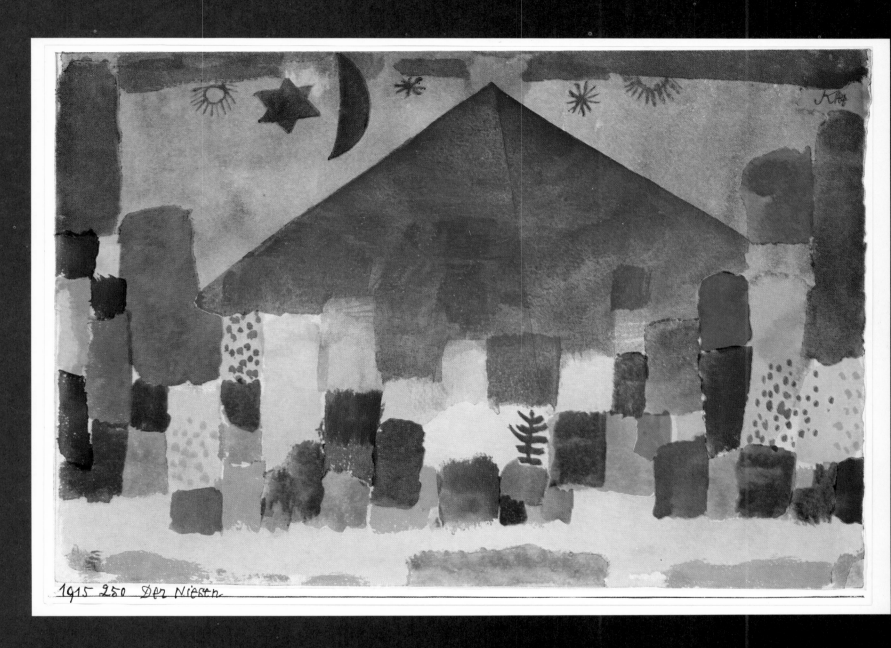

1915 250 Der Niesen

PAINTED IN 1917

Invention (With the Dovecote)

WATERCOLOR ON COLORED PAPER, 8¾ × 6¼″

COLLECTION KARL GUTBROD, COLOGNE

THIS *Invention* (as the term is used in music) stands halfway between the romantic watercolors of 1917–19 and Klee's explorations of pure form during the same period. As he does so often, Klee here proceeds along two paths simultaneously, now emphasizing the playful and dreamlike aspects, now stressing the purely formal order of the work. He lets it grow, and watches as his pictorial adventures produce new realities and insights. There are several layers of consciousness involved in this procedure, resulting in a multiplicity of representational and conceptual dimensions. Since his formal structures always enter into a relationship with the known things of nature, we need not be surprised that these stripes, squares, triangles, circles, and tear-drop shapes suggest some farm buildings and a dovecote; but this happens only at the end, when the forms and colors have evoked a memory of these things in Klee's mind.

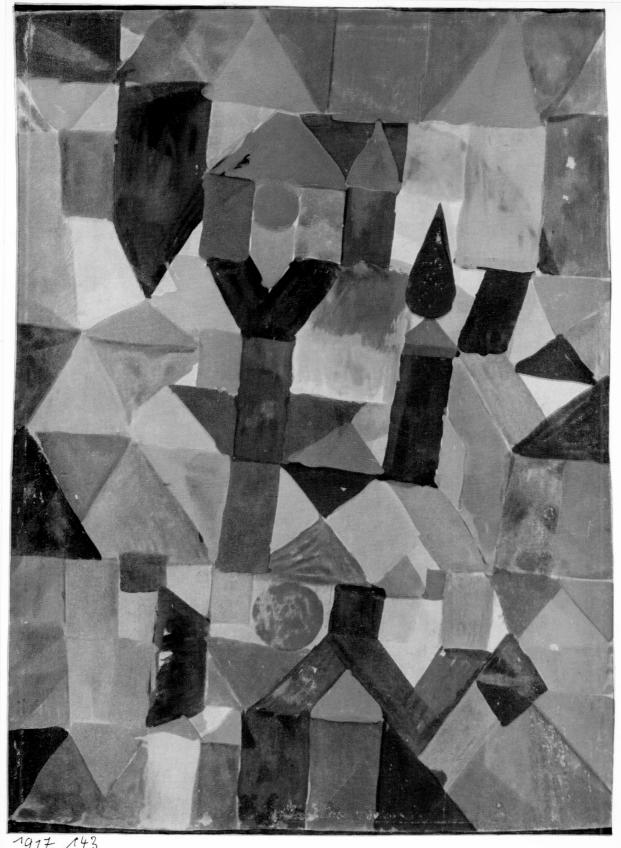

1917 143

PAINTED IN 1923

Battle Scene from the Comic Opera Fantasy "The Seafarer"

WATERCOLOR AND OIL DRAWING ON
COLORED PAPER, 15 × 20¼″

COLLECTION FRAU TRIX DÜRST-HAASS, BASEL

FOR KLEE THE OPERA IS THE REALM of the impersonal: its heroes and heroines have no individual psychological reality. They are symbols—of good and evil, of the pure and of the demonic. The operatic conflicts take place in a sham world, though the unreality of this world conceals a mystery.

In 1921 Klee made a drawing entitled *Lohengrin in the Cinema*. Is *The Seafarer* intended as a parody of Wagner's operas? The plume-crowned tenor, with his red tights, looks like a provincial Lohengrin, and the three sea monsters with their gridded, striped, scaly armor seem to be engaged in a jeering imitation of puppets. The netting, with intersecting stripes, is bluer at the right, and blacker at the extreme left; the two worlds thus distinguished are linked by the blood-red lance. The tenor is in a dark field; the sharks are in the brightest light, as though they were sirens reaching for high C.

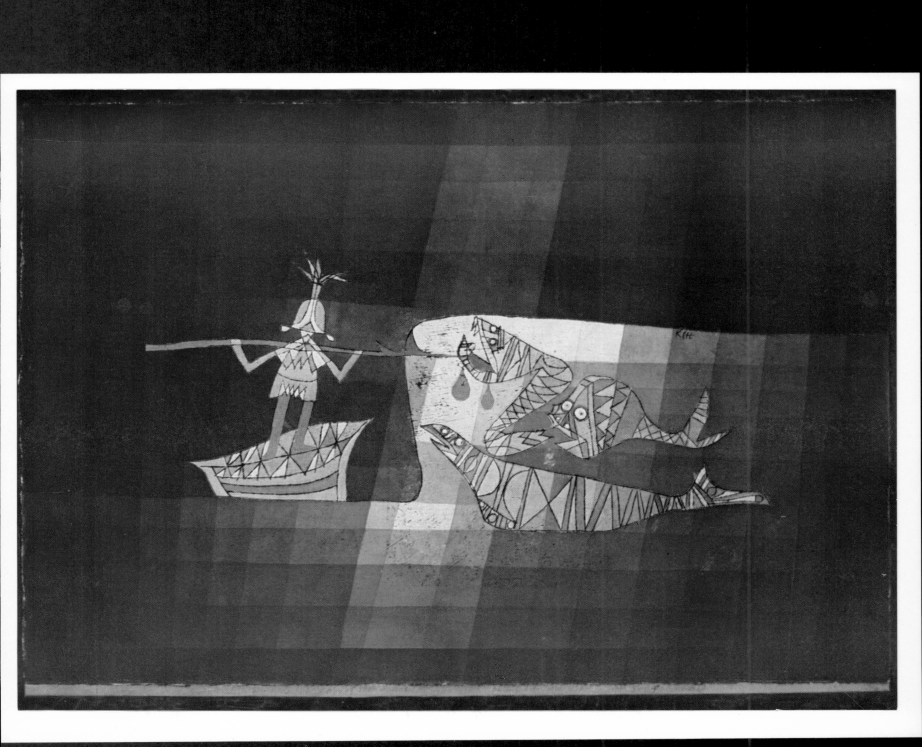

APPARATUS FOR DELICATE ACROBATICS
1922. Pencil drawing
Private collection, U.S.A.

PAINTED IN 1923

Puppet Show

WATERCOLOR ON CHALK GROUND ON

COLORED PAPER, 20¼ × 14⅝″

KLEE FOUNDATION, BERN

THE YEARS SPENT AT THE BAUHAUS in Weimar were the happiest of Klee's life. He did miss several things, however, such as the many concerts and theatrical evenings he had enjoyed during his Munich period. Still, there was some musical life in Weimar, with occasional operas and concerts. Klee's son Felix loved the theater even more than his father did (he became a stage director); he owned a puppet theater which he had brought along from Munich. For this Paul Klee carved the puppets, painted the scenery, and participated in the performances in other ways as well. Unfortunately, most of this material has been lost.

The *Puppet Show* records this intramural amusement at Weimar and is one of the first of the many pictures on theatrical themes which Klee continued to produce as late as his Bern period, from 1933 on.

On a flowery meadow we see a child actress drawn in a childlike way, with a heart-shaped torso and frizzy hair, but very sophisticated in its extreme simplification. At her feet we see a doll and a toy unicorn; a window of colored stripes is on the left; and on the right is a tower with a star at the top. The background is dark, so that the colors look as if they were illuminated from behind—an imaginary stage lighting. This is the naïve counterpart of the picture *Magic Theater*, done at the same time, which, with its monstrous animals and dwarfish puppets, has a weird and spooky effect reminiscent of Bruegel.

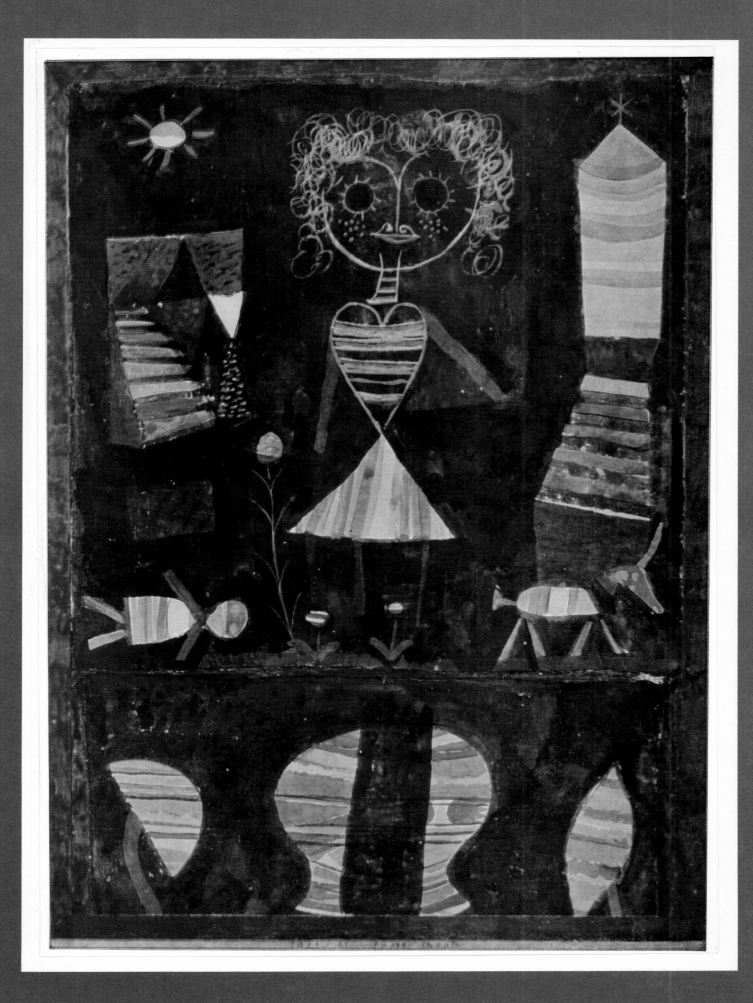

PAINTED IN 1923

Ventriloquist
(Caller in the Moor)

WATERCOLOR ON COLORED PAPER, 15⅜ × 11⅜″

COLLECTION DOUGLAS COOPER, ARGILLIERS, FRANCE

Ventriloquist BELONGS TO THE GROUP of colored sheets in which transparent horizontal and vertical bands cross and form a kind of screen of varied rectangles. In itself the effect of this pattern is like that of the "magic square" pattern, in which squares and rectangles are put side by side abstractly, somewhat reminiscent of the twelve-tone system in music. But most of the screen pictures contain graphic designs imprinted on the screen by transfer or rubbing. In this way Klee links the poetic element of the design with the poetic element of the scene represented.

The *Ventriloquist* is one of Klee's most grotesque figures. The inflated body with its pinks and light blues on the varying browns and olives of the screen suggests a eunuch. Inside the belly are all sorts of animals whose voices are transmitted to us through a gramophone horn. The pitifully small arms are raised like those of a real orator, but they reach into the void, into the brown darkness of the grid. He is a "Caller in the Moor," as we learn from the subtitle. Once we know this, the light pink and light blue tones may suggest a will-o'-the-wisp quality.

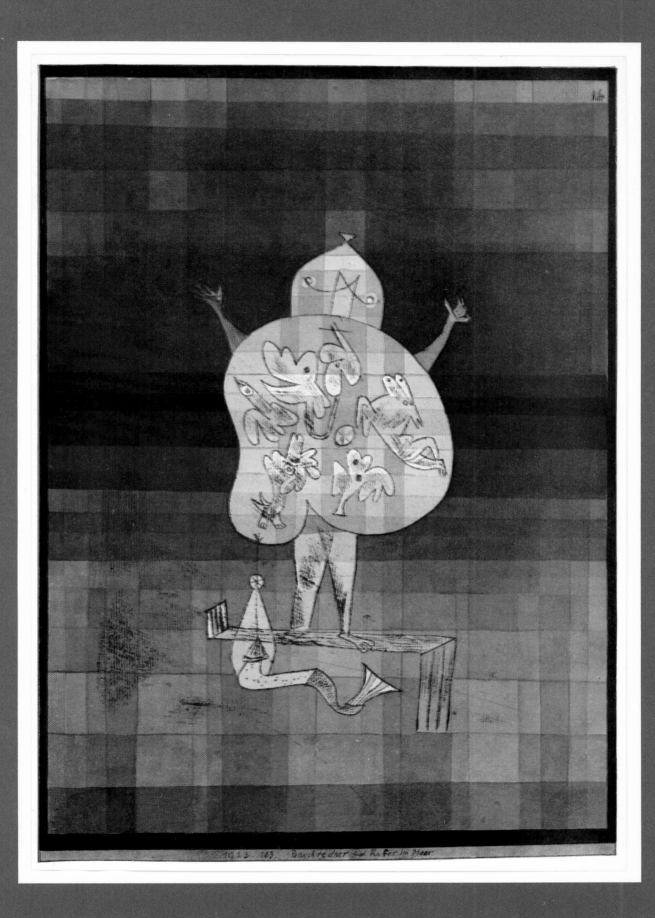

DRAWING FOR "PLANTS, SOIL, AND AIR"
1920. Pen drawing
Klee Foundation, Bern

PAINTED IN 1924

Dance of the Red Skirts

OIL ON PANEL, 13½ × 17″

PRIVATE COLLECTION, BERN

A BALLET ON A LARGE STAGE—probably a Moorish dance. The dancers wear flaming red skirts; their postures suggest that this is not a classical ballet. Klee attended several modern ballet performances at Weimar, but he did not particularly like them. Here the motions are somewhat caricatured; the setting is pretentious, too dark for a ballet. The fragmented figures in the upper part of the picture are poised upside down or on their sides; in the dim light their red skirts look like flickering flames. The restless, menacing character of the painting is enhanced by the mottled color. This work is an example of Klee's spontaneous art; it has nothing in common with his other projects, or with the technical and formal inventions he developed in Weimar.

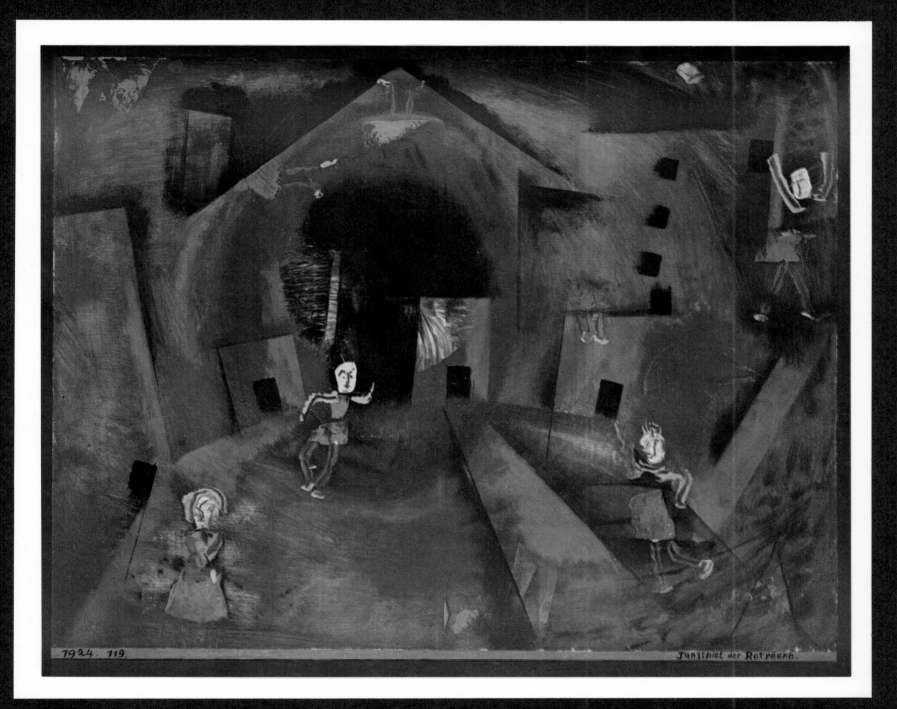

1924. 119. Tanzspiel der Rotröcke

PAINTED IN 1927

Place of Discovery

OIL ON PLASTER GROUND ON PANEL, 18⅞ × 13⅞″

COLLECTION PHILIPPE DOTREMONT, BRUSSELS

IN DESSAU KLEE WENT through a long period of graphic "inventions" of the most varied kinds, which he also used in his watercolors and panel pictures. That was the period of the parallel figurations (*A Garden for Orpheus*, 1926), of free, melodic, and intersecting lines. In 1927 Klee wrote that he had once again plunged into drawing with "barbarous savagery." But this graphic obsession admittedly resulted, by way of contrast, in an intensification of color. Klee refers to color as "the most irrational element in painting," and here too he goes beyond the controllable and predictable. So long as everything is in order, he says, no tension can arise; art begins only "with arbitrary acts of overemphasis." He subjects color to his will, determines its relations to the other elements of the picture, to the objects and forms. Color quality is subordinated to the desired effect; opaque colors suggest closeness, transparent colors, distance.

Place of Discovery is one of several pictures treating the theme of archaeological excavations; Klee liked excavation sites and visited many of them in Italy and Sicily. After 1924 he went to the South every summer. By means of deeply shaded contours and lightly modeled planes, the essential elements are brought out in the picture (as they are brought out of the ground by archaeologists), and pushed forward. We see something like a quarry, ladders, a bridge, and the objects excavated near a barracks. The triangular moldings underline the archaic character of the scene; they are embedded in the same red as the unearthed objects. Opposed to the red is the blue of the river under the arches of the bridge, and the blue of the sky at the upper left. Everything else is warm, stony gray, as though covered by the dust from the excavations. The objects are deliberately made to evoke the disorder usual at archaeological sites.

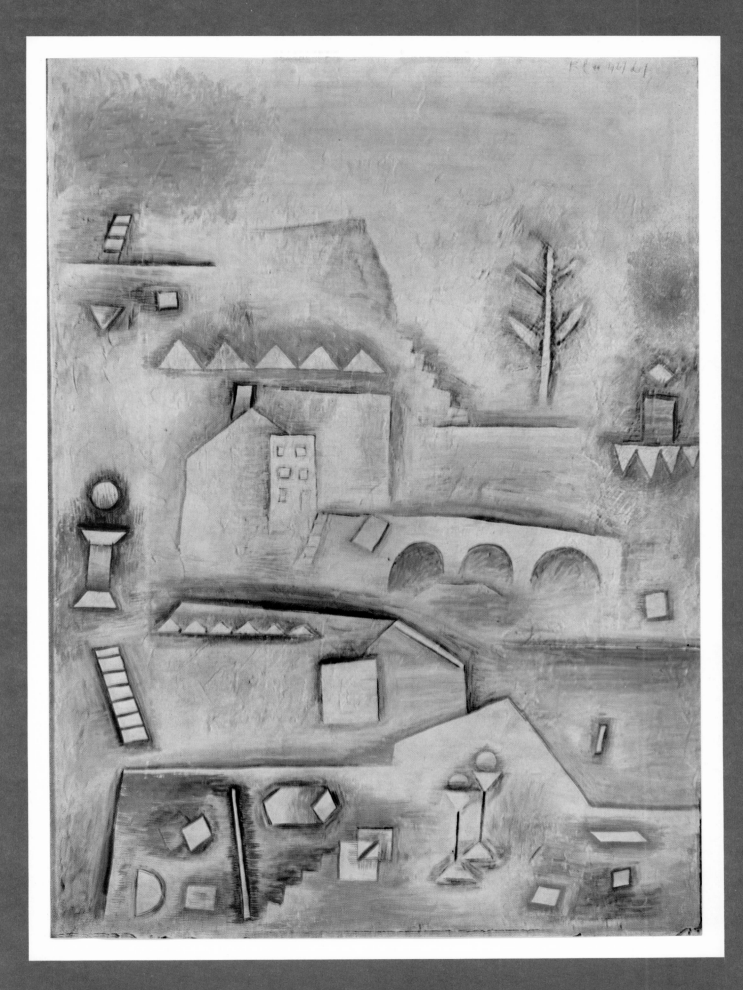

PAINTED IN 1927

City on Two Hills

WATERCOLOR AND PEN DRAWING ON

COLORED PAPER, 10 × 14¼"

COLLECTION MAX FISCHER, STUTTGART

THIS PICTURE IS DEVELOPED from a continuous line combined with other intersecting lines. Klee begins his figuration at one point and draws a series of irregular right angles without stopping. Then, occasionally, he begins another continuous line of the same sort. The areas produced by the intersections are colored and organized, giving rise to works very different in character—pieces such as *Fool in a Trance* (1927), or landscapes such as *Chosen Site* and this *City on Two Hills*. Characteristically, Klee can derive both figures and landscapes from the same pattern with equal ease. The small *Fool in a Trance* is like a choreographic design; the *City on Two Hills* like an architectural drawing. The former suggests movement and rhythm, the latter, with the squares and polygons reminiscent of houses, suggests planning and construction. We almost think that we recognize the city represented here, with its little and big buildings and towers. The summer of 1927 Klee spent in Corsica, and this picture may represent a Corsican town. The colors would justify such a hypothesis—the sky is leaden, the beach is lavender, the houses are pale green and light ocher. The artistic design, the formal invention, come first, but they never run into the void, they always find a response in reality, as though the instinct of the artist's hand and the instinct of nature were only waiting to meet each other.

24

KRH

1927 V.4 Zweihügel Stadt

PAINTED IN 1929

Clown

OIL WITH CHALK ON PANEL, 26¾ × 19⅝″

COLLECTION MRS. GERTRUDE LENART, NEW YORK

ONE OF KLEE'S GREATEST pictorial achievements. It reminds us of Picasso, whom Klee revered, and whose paintings always fascinated him. When Picasso visited him in Bern and expressed admiration for his works, Klee (who was already ill at that time) was gratified.

The oval face divided into sections by a zigzag, the green neck, the clown's costume, the little green hat pushed to one side, the green button on the right shoulder—all these things are as though painted in a felicitous moment, and yet they are balanced down to the last detail. Similarly balanced are the pink and the brown of the face with the green of the neck, the button, and the hat on the brick-colored background. This clown, with his red eye and receding nose, has a quixotic quality; how this comes about remains a mystery. It is the effect of imponderables—the slit of his right eye; the regular, blue mouth; the rigid neck; the provocative, hot background which seems to encourage absurd actions. Daumier attempts to render the psychology of Don Quixote as conceived by Cervantes; Klee gives us a figure which reminds us equally of Aristophanes and of Cervantes, but in fact it is a completely new creation.

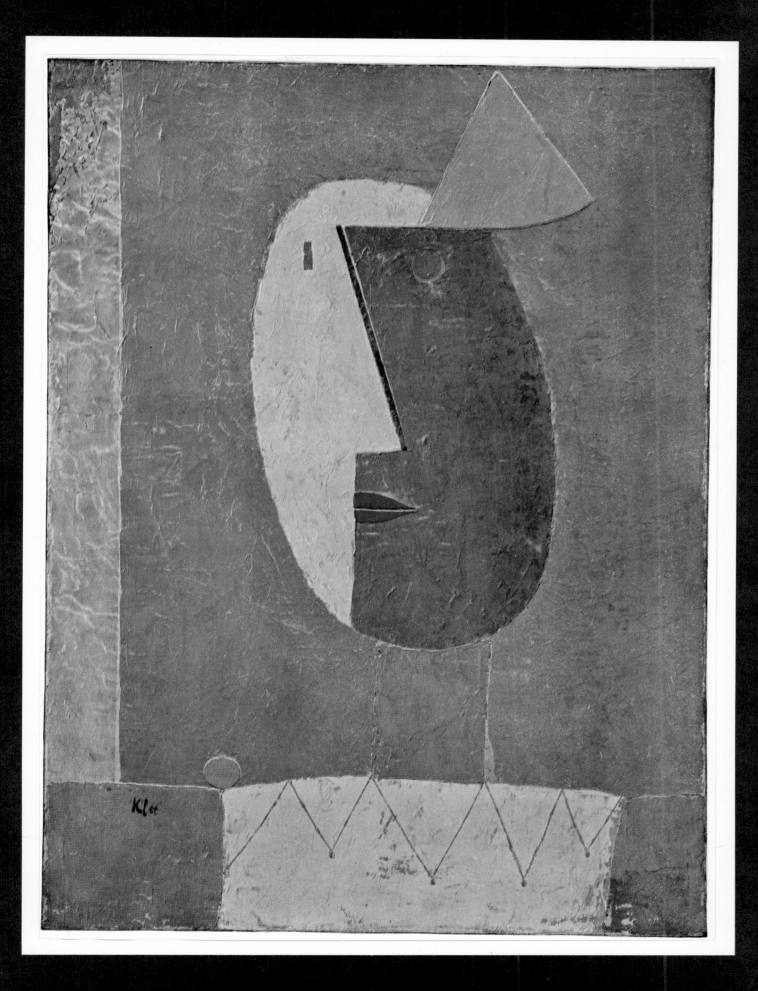

Individualized Measurement of Strata

PASTEL ON PASTE GROUND ON COLORED PAPER, 19 × 14″

KLEE FOUNDATION, BERN

THIS IS ONE OF THE SERIES of Egyptian "landscapes" which Klee painted after his visit to Egypt (December 1928 to January 1929). The series is anticipated by earlier works: two pictures dating from 1924 have the word "Egypt" in their titles. As for the formal conception, this picture reminds us of the fugal, parallel style of 1926. But possibly Klee had been on the shores of the Nile in spirit before actually going there, for *Blue Mountain* of 1919 even more closely resembles an Egyptian landscape.

We see a pattern consisting of horizontal stripes of varying widths, but only a few of these stripes extend all the way across the picture; most of them are cut by verticals. The horizontal organization of the picture is to some extent neutralized by the vertical one, particularly because the stripes within the verticals differ in width and color from the others. Just as in the parallel figurations, the result is a formal structure that seems to express a certain order and has nothing to do with Egypt.

What Klee expected to find in Egypt was not what ordinary travelers expect to find. He was drawn to Egypt as he had been drawn to Tunisia in 1914, because it offered a unique combination of the East and the West, which Goethe had captured for his time in the *Westöstliche Divan*. Already on his way there, in Syracuse, he said that "the right thing is the historical stimulus combined with nature." The simultaneous view of time and space, which Egypt induced in him, became the keynote of his vision and of his art. He penetrated into the primeval past which had been waiting for someone to begin it anew. History and landscape overlap each other in the tilled fields of the Nile Valley, in the pyramids and temples, and the visual experience "reaches a deeper reality." There Klee found his inspiration.

Does *Measurement of Strata* merely represent geological layers or does it, like *Highway and Byways* (1929), embody an aspect of Egypt? Here as elsewhere the pattern, which had probably been latent in Klee before, has connotations both spiritual and physical, and *Measurement of Strata* expresses Egypt no less than *Monument in Fertile Country*, only it is more severe and does not suggest the pyramid form. The green stripe at the bottom of the picture is the Nile, and the light ocher stripe on top is a hill. In between lie fields of various colors; they suggest layers, but also express a human order. This is an allegorical picture that does not reveal its secret.

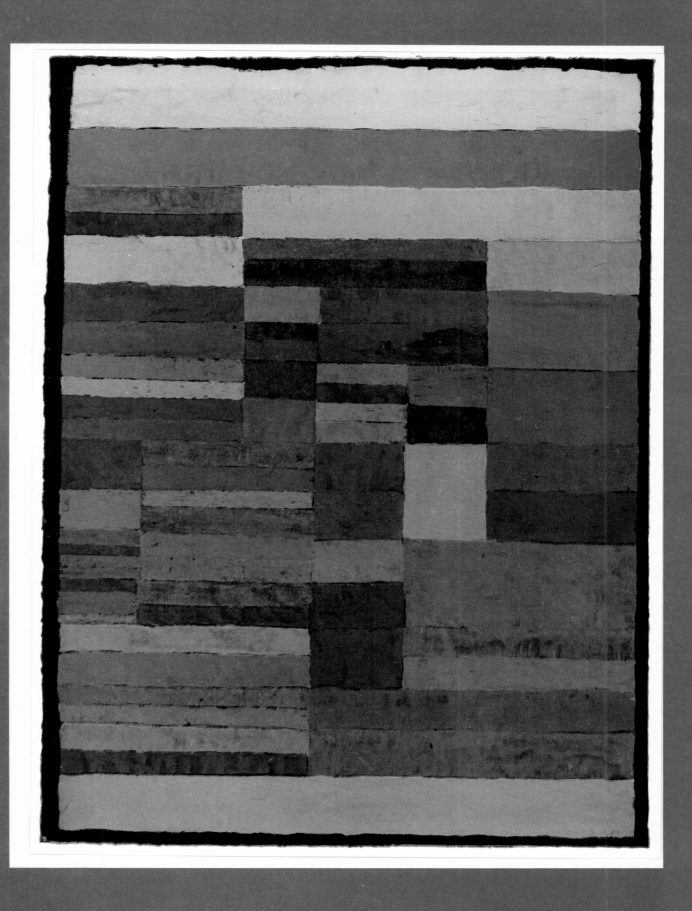

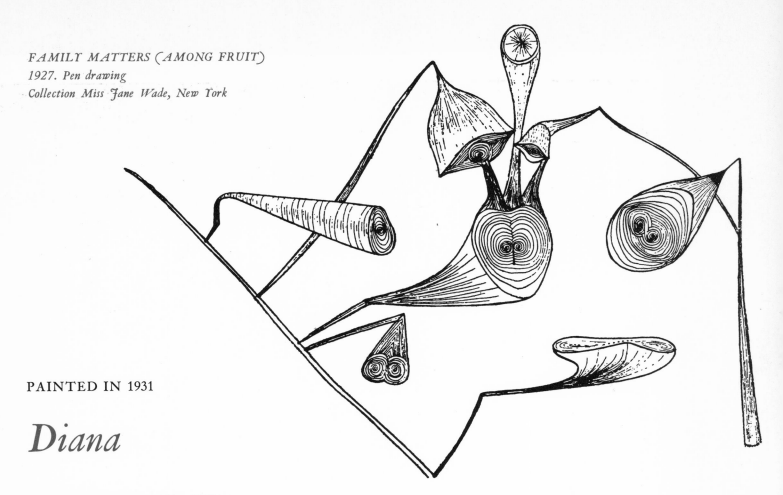

FAMILY MATTERS (AMONG FRUIT)
1927. Pen drawing
Collection Miss Jane Wade, New York

PAINTED IN 1931

Diana

OIL ON PANEL, 31½ × 23⅝″

COLLECTION MRS. GERTRUDE LENART, NEW YORK

AT THE END OF 1930 Klee arrived at a new, very important conception, which he called "divisionism." He treated colors in the manner of Seurat and the Neo-Impressionists, but he did not split them in order to achieve greater luminosity, nor did he arrange them according to what was called "simultaneous contrasts"; instead, he worked with rows of dots of the same color, which he placed on a ground that is only slightly articulated into planes and colors. The result is a kind of colored, light-filled space, a counterpart of the physical space obtained from interlocking planes. Several of Klee's pictures seem to have been waiting for this light-filled space before they came into being, and they too can be classified as "divisionist." Some of these are quite abstract, or, as Klee preferred to call them, "absolute," while others have graphic elements which evoke identifiable objects by way of association.

To the latter group belongs this *Diana*, done in 1931. The colored light here has the effect of a "divinatory being," to quote a phrase by the poet Novalis, and it is both a spiritual and a physical phenomenon. The distinction between "within" and "without" is no longer valid, Diana is a fleeing, flying being, her left foot touches a wheel; the figure is a structure composed of fluttering forms, the tiny head is of little importance. More important is the arrow which denotes movement, seeing, and apparently also hunting. The dominant, nocturnal green is Diana's home, she moves on it like a planet, for she is, among other things, a moon-goddess.

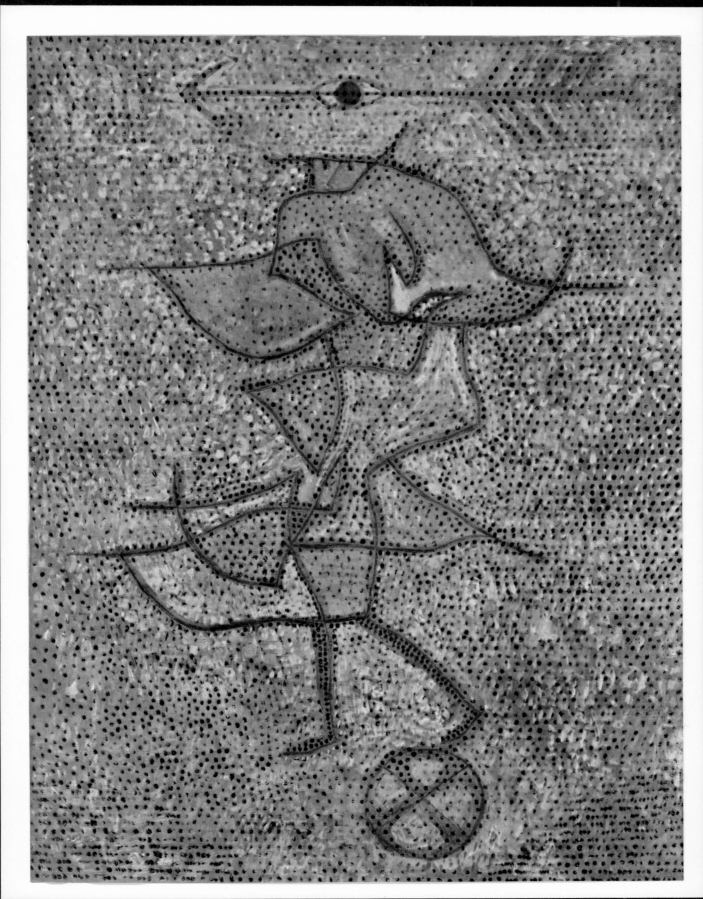

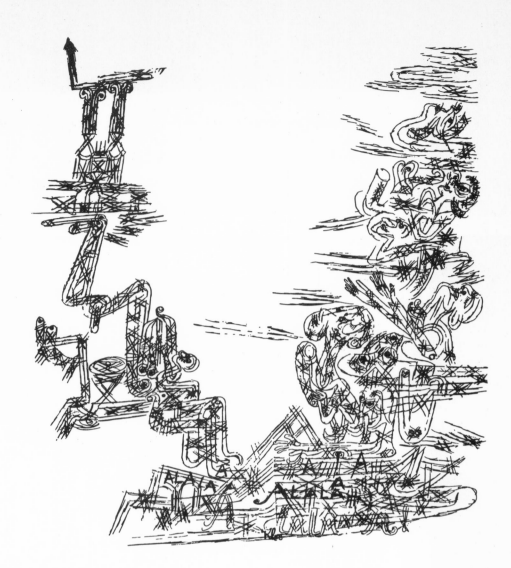

PAINTED IN 1937

Stage Landscape

PASTEL ON COLORED PAPER, 22⅞ × 33⅞″

COLLECTION HERMANN RUPF, BERN

FROM KLEE'S WEIMAR YEARS we have a large number of theater pictures. Similar themes and titles often occur, as on the opposite page and in an earlier painting of the same title done in 1922. None of these pictures are governed by any definite structural laws bound up with the concept of theater; they adapt themselves rather to nearly all the permutations of Klee's pictorial form. That is where they differ from the magic squares and the fugal pictures; the factor they have in common with them is that they, too, belong to a world that has a logic of its own.

Stage Landscape, with its yellow and red and its green and purple accents, is a backdrop, perhaps, for *The Magic Flute.* Colors and contour correspond like music and text; the little tree in the center might be the dance of the little bells, and the dark powers dwell in the depths of the purple, brown, and green. It is the colors that carry the tune; the text is an accessory.

32

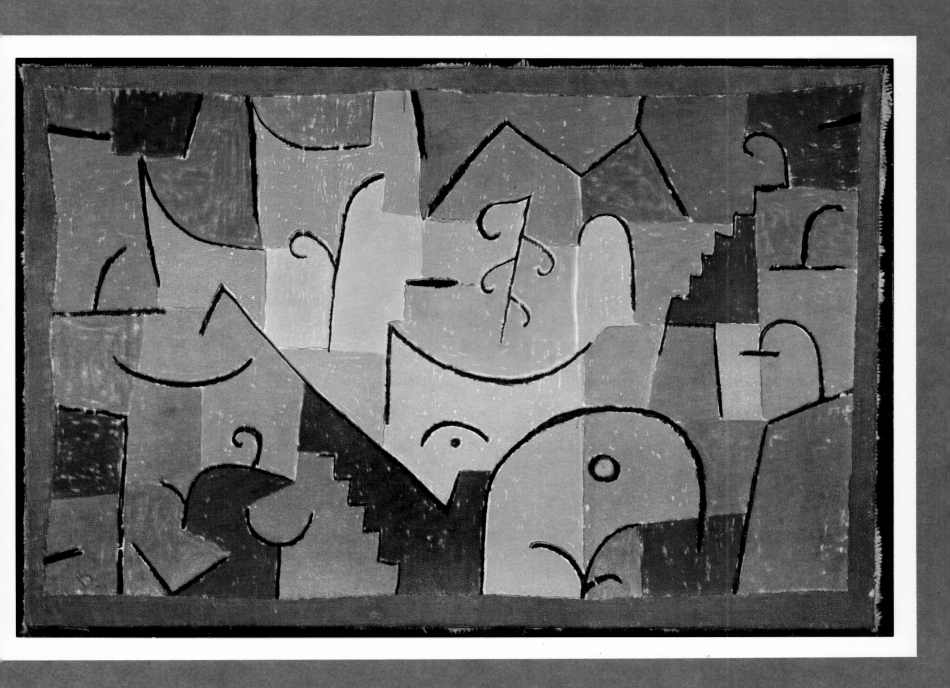

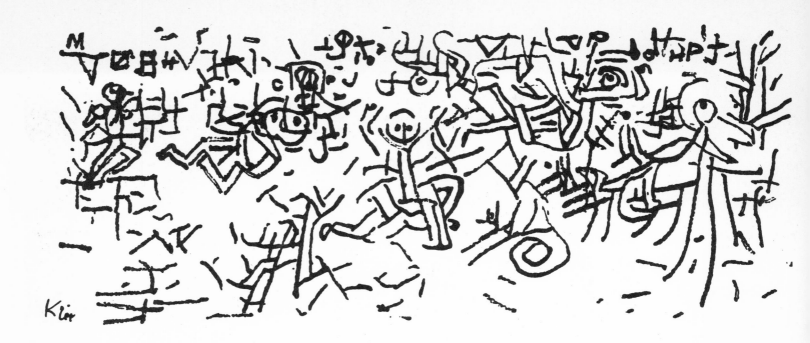

REVOLT IN THE PLAINS
1932. Pen drawing
Formerly Collection Curt Valentin, New York

PAINTED IN 1938

Coelin Fruit

GOUACHE ON COLORED PAPER, 14⅛ × 10⅝″

KLEE FOUNDATION, BERN

UNLIKE THE STROKES IN *Stage Landscape* the heavy, dry-brush strokes in *Coelin Fruit* are loose and delineate objects. A curious contrast between sky blue and wrapping-paper brown, between the brilliance of the fruit and the dullness of what surrounds it, characterizes this still life. The veins on the leaf look like the bones of a skeleton, the flowers and the pistils like instruments of some sort. *Disjecta membra*—scattered fragments—that barely touch each other and are in measurable spatial relation to each other. It is as though sky and earth met; the coelin-blue fruit, with its attributes, is seen on an earth-brown ground. In pictures such as this one, Klee achieved the ultimate simplicity he had aimed at from the outset; he achieved it with the most direct means, after trying out all the potentialities of pictorial art and taking the longest possible detours.

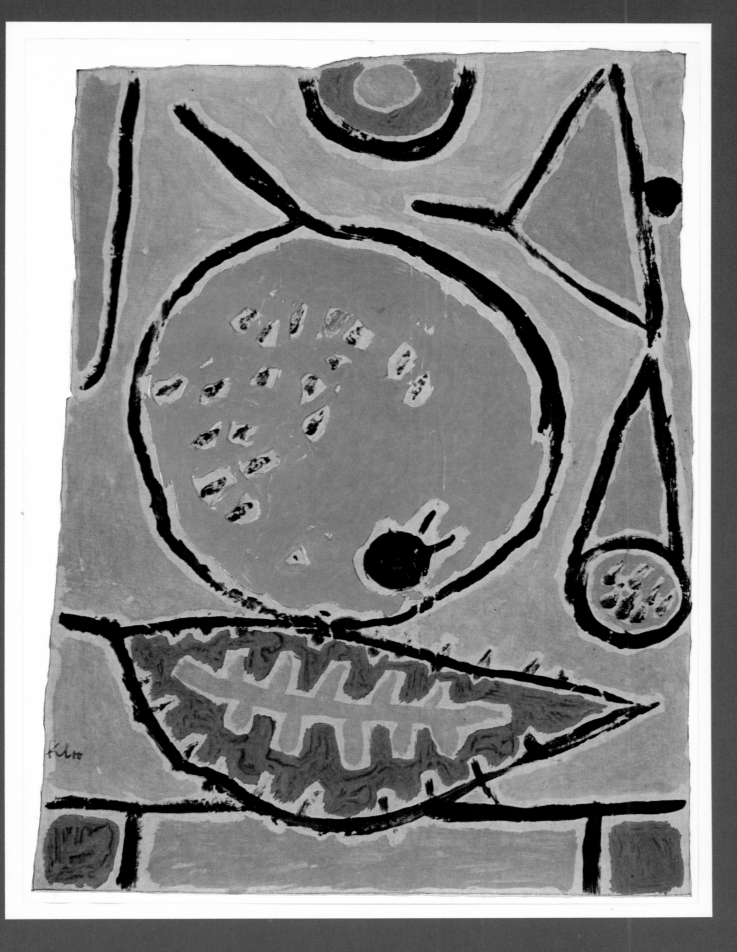

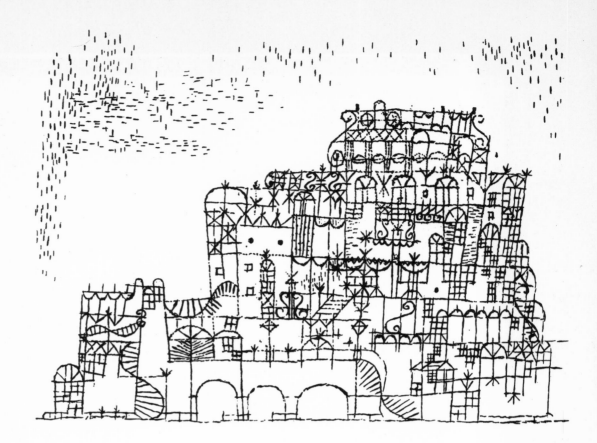

PAINTED IN 1940

Woman in Native Costume

GOUACHE ON COLORED PAPER, 18⅞ × 12½″

KLEE FOUNDATION, BERN

SHORTLY BEFORE HIS DEATH, Klee produced pictures and figures like this *Woman in Native Costume*, which, composed of a few harsh strokes enclosing colored shapes, have the effect of leaded stained-glass windows. The figure of "a woman in native costume" emerged only at the end of a long process—when the triangle on white was associated with a nose, and led to the two black dots that mark the eyes. In other pictures, similar forms led to landscapes or non-representational forms.

In the course of a conversation Klee said one evening that when he made this drawing he was so excited that he had the feeling of beating a drum. We cannot help recalling these words when we look at such pictures. The lines and the colors have something in them of drumbeats, which are limited in mood but all the more emphatic for that. Actually, Klee painted a drummer and drumbeats, to commemorate a drummer whom he had heard and observed at the Dresden Opera House.

The form of the picture has something of the quality of a Gregorian chant, and its expression is religious rather than secular. The strong red, which is much emphasized in Klee's last works, hints at the consuming fire of the realm of the dead.

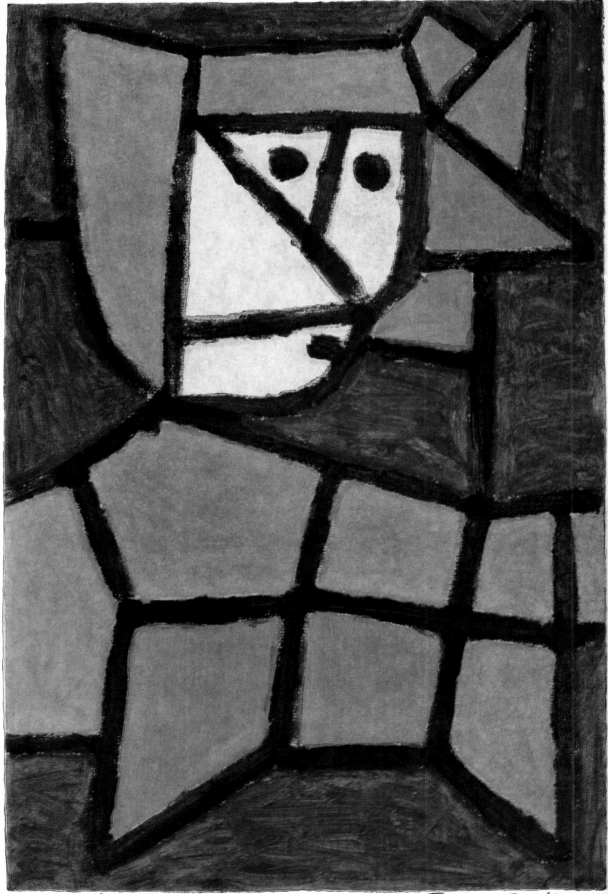

1940.M14 Frau in Tracht

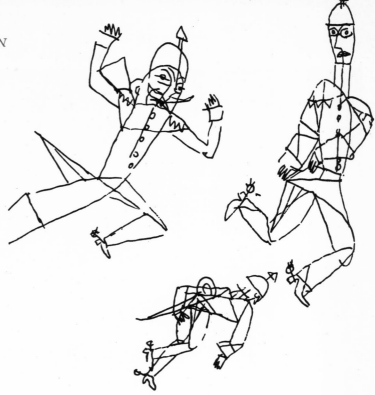

THE FLEEING POLICEMEN
1913. Pen drawing
Klee Foundation, Bern

PAINTED IN 1940

Still Life

OIL ON PANEL, 39⅝ × 31½″

COLLECTION FELIX KLEE, BERN

KLEE'S LAST WORK, which he did not sign or caption. Apparently it represents a domestic scene, with a table on which a green coffeepot and a pale violet sculpture are placed. Flowers are scattered over the orange cloth; they look like letters of an alphabet. At the upper left there is a red table-top with vases, one of which has an armlike appendage and red flowers. The background is of the deepest black, with a moon yellow as the yolk of an egg.

All of a sudden the picture seems sinister. The intimacy of a still life seems to have changed. The black is the night, and the moon does not illuminate it. The flowers on the table are transformed into artificial flowers like those thrown into graves. But there is a clue to the riddle—a white card at the lower left, near the frame. On the card we see a winged figure held back by hands clenched into fists—probably an image of Jacob wrestling with the angel. Jacob was one of the elect; thus Klee's last work offers us a parable of hope for life beyond death.

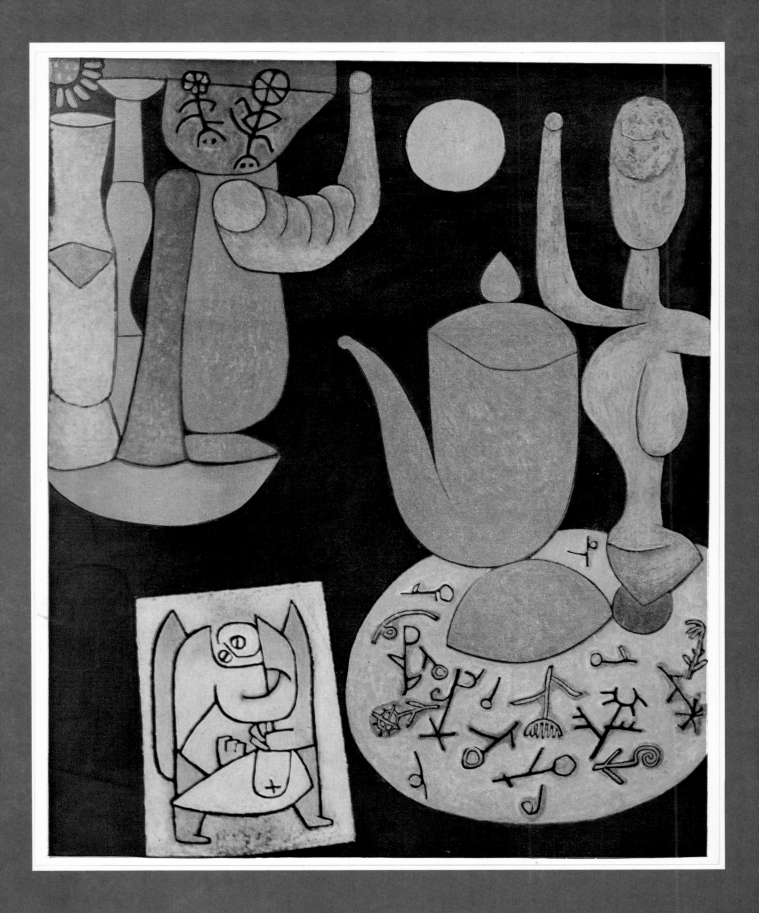

LANDSCAPE WITH ADVENTURERS
1924. Pen drawing
Private collection, U.S.A.

ON PAGE 7

PAINTED IN 1910

Girl with Jugs

OIL ON PANEL, $13\frac{1}{2} \times 10\frac{5}{8}''$

COLLECTION FELIX KLEE, BERN

THE *Girl with Jugs* IS SAID TO BE Klee's earliest extant painting. Before this, in 1909, he had done a small, realistic oil painting of a girl in a field, but this has been lost. In 1910 Klee had given up doing pictures on glass, but he retained his interest in "tonal" watercolors, that is, watercolors in monochrome or black-and-white.

In his diary he wrote on his thirtieth birthday: "From now on I must be myself; realistic appraisals and no artificial onward-and-upward-with-the-arts!" He was planning his course with respect to color. He was thinking of the painting process as a campaign—a campaign based on such "strategic concepts" as the "white terrain" of the picture, large spots of contrasting colors without intermediate shading or transitions, and superimposed on them a line drawing to make up for the lack of tonal values.

In 1909 Klee had seen pictures by Cézanne at the Munich *Sezession,* and had come to know the work of Matisse at the Thannhauser Gallery. The *Girl with Jugs* reflects the influence of Cézanne to some extent, through its sense of volume and the measurable quality of its space, which is emphasized by its downward angle of vision, as well as through its use of related tones in defining the form. The red and blue tones and the rhythmic, sharp contours are reminiscent of Matisse.

It would seem that Klee started from the round forms of the jugs and the glasses and attempted to bring the human figure into accord with them; having used blue as the basic color, he was led to the contrasting red accents. The result is a picture that sums up the state of European painting and of Klee's own style at that time, with strong personal touches, especially where the grotesque, and quite un-French, quality of the girl's expression is concerned. This last is an echo of his painting on glass.